DISCOVERIES

DATE

DISCOVERIES

DATE

DISCOVERIES

DATE

DISCOVERIES

DISCOVERIES

DATE

DISCOVERIES

DATE

DISCOVERIES

DATE

DISCOVERIES

DATE

DISCOVERIES

DATE

DISCOVERIES

DISCOVERIES

DATE

DISCOVERIES

DATE

DISCOVERIES

DATE

DISCOVERIES

DATE

DISCOVERIES

DATE

DISCOVERIES

DATE

DISCOVERIES

DISCOVERIES

DATE

DISCOVERIES

DATE

DISCOVERIES

DISCOVERIES

DATE

DISCOVERIES

DATE

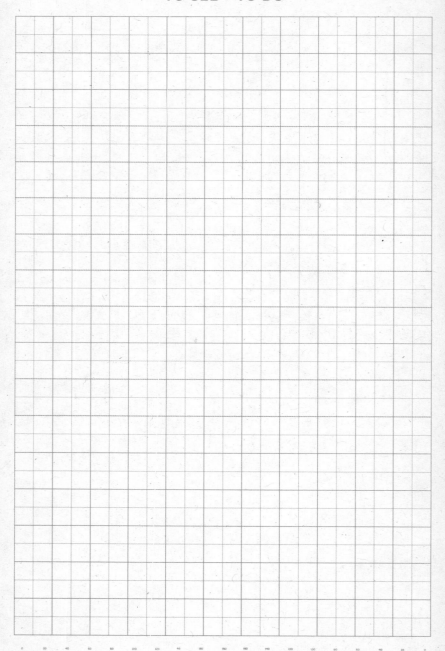

DISCOVERIES

DATE

DISCOVERIES

DISCOVERIES

DISCOVERIES

DATE

DISCOVERIES

DATE

DISCOVERIES

DISCOVERIES

DATE

DISCOVERIES

DATE

DISCOVERIES

DATE

DISCOVERIES

DATE

DISCOVERIES

DATE

DISCOVERIES

DISCOVERIES

DATE

DISCOVERIES

DATE

DISCOVERIES

DATE

DISCOVERIES

DISCOVERIES

DISCOVERIES

DATE

DISCOVERIES

DISCOVERIES

DISCOVERIES

DATE

DISCOVERIES

DATE

DISCOVERIES

DISCOVERIES

TO SEE • TO DO

DISCOVERIES

DISCOVERIES

DISCOVERIES

DISCOVERIES

DATE

DISCOVERIES

DATE

DISCOVERIES

DATE

DISCOVERIES

DISCOVERIES

DATE

DISCOVERIES

DATE

DISCOVERIES

DATE

DISCOVERIES

DATE

DISCOVERIES

DATE

DISCOVERIES

DISCOVERIES

DATE

DISCOVERIES

DISCOVERIES

DISCOVERIES

DATE

DISCOVERIES

DISCOVERIES

DISCOVERIES

DISCOVERIES

DISCOVERIES

DISCOVERIES

DATE

DISCOVERIES

DATE

DISCOVERIES

DATE

DISCOVERIES

DISCOVERIES

DATE

DISCOVERIES

DATE

DISCOVERIES

DISCOVERIES

DATE

DISCOVERIES

DATE

DISCOVERIES

DATE

DISCOVERIES

DATE

DISCOVERIES

DATE

DISCOVERIES

DISCOVERIES

DISCOVERIES

DATE

DISCOVERIES

DISCOVERIES

DATE

DISCOVERIES

DATE

DISCOVERIES

DISCOVERIES

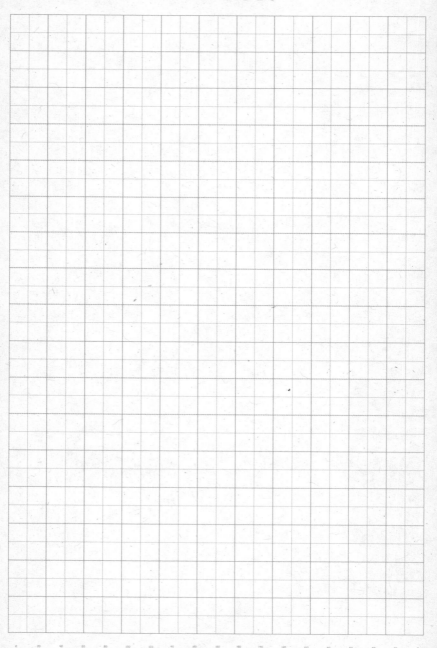

DISCOVERIES

DISCOVERIES

DATE

DISCOVERIES

DATE

DISCOVERIES

DISCOVERIES

DISCOVERIES

DATE